CELTIC DESIGN

Aidan Meehan studied Celtic art in Ireland and Scotland and has spent the last two decades playing a leading role in the renaissance of this authentic tradition. He has given workshops, demonstrations and lectures in Europe and the USA, and more recently throughout the Pacific North West from his home base in Vancouver, B.C., Canada.

CELTIC DESIGN

THE DRAGON AND THE GRIFFIN
The Viking Impact

AIDAN MEEHAN

With 220
illustrations

Thames & Hudson

This Book is Dedicated to Oisin who Inked while I Pencilled

Artwork: pencil, Aidan Meehan;
inking, Oisin Meehan, *figs.* 10-14, 21, 63,
69, 73, 75, 76, 79, 90-103, 104-112.

artwork and typography
copyright © 1995 Aidan Meehan
Reprinted 1999

First published in the United States of America in 1995
by Thames & Hudson Inc., 500 Fifth Avenue,
New York, New York 10110

Library of Congress Catalog Card Number 94-60346
ISBN 0-500-27792-3

Printed and bound in Spain

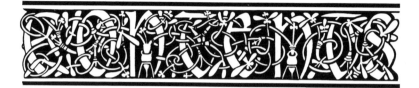

Fig. 1 Griffin Mask, Tuam, Ireland, 12th century

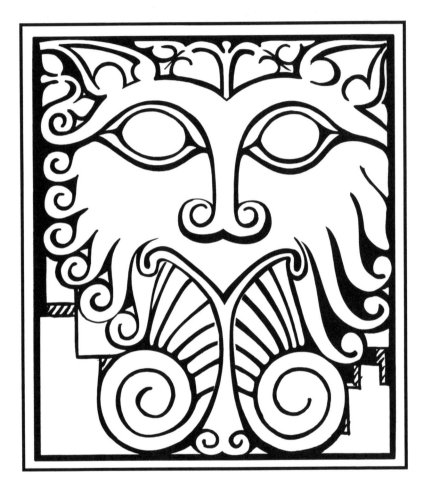

This may be read as a lion mask with a pointed beak, or a cat with big head and a small body.

HE APPEARANCE OF
SCANDINAVIAN STYLES in
Celtic art after 800 AD harks
back a couple of centuries to
when Irish monks introduced
interlaced animals into Celtic
Art as a result of missionary contacts
with the Continent, which by that time
was mainly Germanic.

By *Germanic*, I mean all the family
of nations originating in Scandinavia that
took over the Western Roman Empire,
and eventually became most of Western
Europe: Swedes, Swiss, Norwegians,
Normans, Danes, Jutes, Goths, Angles,
Franks, Saxons, Germans, Austrians, Lom-
bards, Burgundians, not to mention
Visigoths of Spain, Ostrogoths of the
Adriatic, Vandals of the Mediterranean
world, *etc.*

Introduction

In general, Germanic peoples speak Teutonic. Celts speak P- or Q-Celtic. "P-Celts", Welsh and Bretons, Manx and Cornish share Brythonic, the languages of the Celts of south Britain, from Welsh *Brython*, Britons, which in turn comes from Old Celtic, *Brittones*. "Q-Celts", Irish and Scots, share Gaelic.

Compare the words by which P-Celt, Q-Celt, Gael and Briton respectively, once called themselves in their own tongues. Pytheas the travel writer reported that the northern inhabitants of the "Brittonic" Isles called themselves *Pretannes*: obviously P-Celts, hence the Welsh word *Brython*, where "B" is a voiced form of the consonant "P", both explosive lip sounds.

Other Greek observers in mainland Gaul mention that the inhabitants there call themselves *Keltoi*, whence the Latin, *Celti*, which goes to show that the word

Celtic is properly pronounced with a hard initial "Q" instead of an "S" sound.

Presumably, on first meeting Gauls, the Greeks approximated the name by which these Goidelic (Gallic) Celts called themselves, which sounded like "Keltoi" to Greek ears: "Kel-" being the same root as "Gal-", meaning Gaul or Gael.

This word Keltoi was clearly "Gallois" in some local Q - Celtic dialect, spoken with a thick brogue such as still pronounces "Celtic" as "Keddel-tic" and Gaelic as "Geddel-ic", in parts of Ireland nearest what used to be ancient Gaul. Hence the Greek "Keltoi" may have been derived from either. The struggle for the Greek tongue to decipher the accent gave rise to the Greek nickname for the native people of Western Europe, that is, "barbarians", (barbarous, "foreigner") from a root meaning, "to stammer", or speak with a thick brogue.

These Gauls may well be ancestral
to the Gaels, the *Scotti*, speaking the Q-
form of Celtic, who may have migrated
to the British Isles about three hundred
years before Christ.

Pytheas was recording a comment
from maybe 500 BC, identifying the older
denizens of Scotland as *Pretanni*. We can
be sure these were the Picts, known in Irish
as Cruitne, i.e. *Pr-t-ni* with a P-Q
exchange, just as the founding saint of
Ireland was called *Patricius* in his native
Roman Britain, and Cothraige in ancient
Ireland.

But remember that common language
does not necessarily mean racial or
national identity, so that an art form
may be shared equally by different races,
which makes a knot – inextricable to all
but specialists – of the issue of stylistic
origin or interchange between Celtic and
Scandinavian art between c. 650 and 1150.

Still, from their first appearance in the Book of Durrow, now generally dated to c. 625–650, animal patterns in Celtic art took on a style of their own.

Obviously this was the fruit of a well-matured tradition, implying that Irish monks absorbed Pictish animal style not long after St Columba (Lat. *Columba*, Dove; Ir. *Columcille*, Dove of the Church) founded Iona in Scotland in 563.

Columcille founded a number of monasteries in Ireland, including Durrow and Kells, but Iona soon became the hub of a network of monasteries bringing Christianity first to the Picts of Scotland and Germanic peoples of Europe, and later to the English of Northumbria.

Iona soon became the "Mecca of the Gael", the epicentre of Celtic Christianity outside of Ireland, and, while still tied

umbilically to Durrow, provided the forge in which the Celtic and Germanic styles of animal ornament were first welded together. Towards the end of the sixth century, Irish scribes had set about developing a canon of sacred art suited to their millennial vision of a new world order in which divisions, whether of language or race, would be transcended, albeit in Christ.

True to Middle Eastern tradition, whence they had received the art of book making and to which they turned as the source of Christianity, they adhered strictly to that aniconic, hieratic form of art normally used among traditional peoples: this inheritance of abstract pattern particularly suited them in view of the second commandment forbidding realism in art.

In seeking a source for the introduction of German animal ornament

into Celtic design, it is important to remember that these monks were scarcely inspired to emulate, much less canonise an "outlandish" ethnic artform belonging to aliens with whom they shared neither language nor creed, nor as yet the art of the book.

Rather, at the time when Coptic knotwork and then German animal patterns first entered the scribes' repertory of ornament, numerous Celtic monasteries on the continent were in continual contact with their Irish mother-centres. The Irish monks added to their evolving canon of sacred art those symbolic forms used by fellow Christians at religious houses abroad.

Many such houses had been founded by Irish teachers like Columbanus (Ir. Colum Ban, White Dove), who opened the gates for peregrinating Irish artisans to pour through Italy, Switzer-

land and France to Britain in the late
sixth century. One of the first missions
from Ireland, led by Columcille from
Iona, was to convert the Picts of
Scotland. This took him across Pictland
as far as Inverness, where he worked
briefly with Columbanus, on the
latter's way to Germany. Columcille
had already founded many schools in
Ireland, including Durrow and Derry,
but Iona soon became the centre of a
web that served first the Picts and then
Northumbrians, linked to centres
founded by Columbanus in the
Germanic heartlands.

The generation that came after
Columcille launched the mission to
the Anglo-Saxons from Lindisfarne
Abbey, founded from Iona in 634.
Lindisfarne remained an Irish outpost
in Northumbria for the next thirty
years.

The Picts adopted the organisation of Celtic Christianity partly because it was Celtic – as they were themselves – and partly because it tried to accept as much as possible of local tradition into the life of the church. At first Celtic spirals became the basis of early Irish Gospel book decoration.

Similarly, Pictish models were used to portray the animal symbols of the Evangelists in the Book of Durrow by the early to mid-7th century. For example, compare the lion symbol in the Book of Durrow, *fig. 3,* to the Pictish Dog symbol at *fig. 2.*

George Bain constantly emphasised the precedence of Pictish animal style at the fountainhead of the "Hiberno-Saxon" style of Celtic art in his seminal book, "Celtic Art: The Methods of Construction".

More recently, the emphasis has been placed on the role of Northumbria

Fig. 2 Dog Design from Pictish
 Carved Slab

as the source, even to see the dog of
the Book of Lindisfarne as representing
a Northumbrian greyhound, as if it
were a local invention! But in fact the
dog of Celtic art does not represent
any particular species, unless there is
one that can extend the length of its
jaws, swap heads with lion or eagle,
develop prehensile lips on occasion and
turn them into knots. Rather, since
the Iron Age the dog was a
sacred totem in
Celtic lore
with mythical
associations to
both Gael and
Pict. The dog at
fig. 2 perfectly
accords with
the metalwork techniques of Celtic
jewellery, and it also suggests an exact

Fig. 3 Evangelist Symbol, Book
 of Durrow

prototype for the animal style of early
Northumbria. The lion at *fig.* 3 has
taken its paws from a Germanic model,
but its resemblance to the Pictish dog
is convincing in its general profile,
especially the tail, head and protruding
tongue. The swirling forms on the hip,
belly, and chest exactly parallel those
of the famous Pictish bull of Burghead,
fig. 4, but the scribe seems to have
given these a hint
of letter form, the
tail being an L,
the belly an N,
and the neck IS,
perhaps a pun
on (*imago*) *Leo-
nis,* the title of
the lion symbol
in Celtic gospel books.

Fig. 4 The Burghead Bull

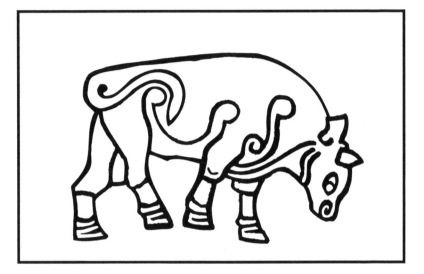

In any case, the style of the lion of Durrow is no doubt Pictish in origin, by an artist familiar with several Pictish prototypes, if not the Burghead Bull itself. When we come to the animal interlace of Durrow, the style is the same as that of the lion, but the form is derived from a German prototype.

Fig. 5 Germanic Animal Style,
 Hintschingen, Germany, c. 600

In the sixth century, the Germans
created interlacing animals such
as this motif based on a gold-foil
cross pattern from Hintschingen,
Germany. It has a lower jaw
crossing over the upper,
 drumstick thighs
 and a banded
 foreleg.

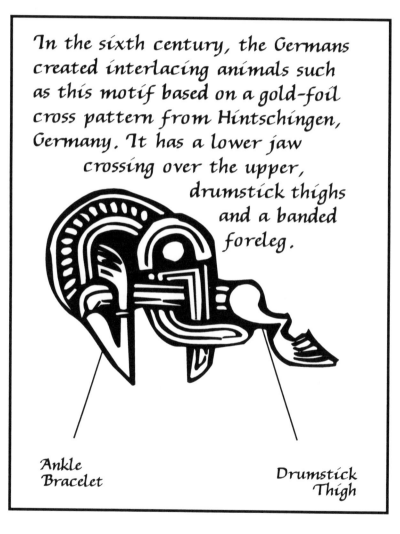

Ankle
Bracelet
 Drumstick
 Thigh

Fig. 6 Border, Book of Durrow

We should look to a Christian
context in Europe around 600 for a
source of the Durrow animals, thereby
allowing for a generation to evolve the
virtuosity of style displayed in the
animal designs of the Book of Durrow,
c. 625. I find the form of the beasts of
the Hintschingen cross, *fig. 7*, to be close
to that of those in Durrow, *fig. 6*.
Significantly, the Hintschingen pattern is
associated with Christian burials.

The monasteries in Ireland had
always encouraged learning, and were
highly valued by local kings. Royal

Fig. 7 Border, Hintschingen

children were sent to school to learn Latin, the language of diplomacy and cultivated discourse, ethics and other such virtues as might have been thought to befit a courtier in the civilised world of the time.

Latin was the *Lingua Franca*, in which the educated spoke freely in public places of matters otherwise forbidden in the vernacular. Younger princelings were sent into monasteries to prevent them staying at home and getting into trouble, or to protect them in dangerous times.

In any case, there at the abbey it was possible to learn all that was needed to succeed either in the world or in the church; to learn a trade, to travel, to hone the powers of intellect, imagination and creativity, or to follow the rule of a saint and the life of prayer, in peace. If in the end, a royal student chose to turn from cell to sceptre, the realm benefited from having an educated ruler; while those who became monks and nuns brought rich endowments and lifelong patronage from relieved parents or grateful siblings.

There was an Irish tradition of going on a missionary expedition, called the "white martyrdom" of voluntary exile, such as undertaken by Columbanus among the Germans, and by Columcille to the Picts. Apart from Latin, Irish became a familiar tongue in many major centres throughout Germanic Europe.

Ireland had never been part of the Roman empire, but with Christianity, she came into an inheritance of classical ideas. The excellence of Irish education attracted students from Britain and the continent, among them royalty as well as clerics, many of whom by the seventh century were of Scandinavian descent. As a result, quite a number of Irish abbeys came to resemble universities, peopled by families attached by hereditary privilege or obligation, all sorts of craft workers and their apprentices, tenant farmers, refugees and visitors as well as students and priests. They were the nearest thing to the first cities in Ireland before the Vikings.

Out of these "multitudinous cities" poured a stream of pilgrims, saints and sages trekking along the hostel routes of Europe and the Middle East: droves of wanderers, men and women, young and

old, on foot and horseback, some wearing
multicoloured plaids and chequered
linens. The wealthier wore linens
creased in patterns, folded origami-style
and pressed beneath their pillow-stones
at night. Others may have amused each
other on the way with bagpipes and
with tambourines, little harps or bells.
Boys carried leather satchels packed with
books being lent to distant libraries, or
relics being exchanged for coveted
manuscripts, to be delivered by returning
pilgrims.

They must have startled bystanders
with their Mardi Gras appearance, the
eyes of both sexes outlined with
turquoise: women, with tattooed palms
and hennaed feet, with three red dots or
blue triangles on their white cheeks;
men with crescent moons, or stripes, or
lozenges shaved into theirs; red-bearded
monks with yellow tresses and frontal

tonsures – foreheads shaved from ear to
ear; beards of every shape and size, long
and short, cut round or square, waved
and forked, or multi-parted; and
moustaches – ribboned, beaded,
ringleted, or strung with bells and
dyed.

Perhaps even more startling to the
onlooker, these early pilgrims founded
stable communities that provided oases
of civilisation during storms of conquest,
grew into centres of learning and culture,
and in many cases famous towns, great
cities and even the occasional capital of
Europe.

At the close of the eighth century
the first Viking expeditions raided the
coast of Ireland. The royal courts were
strong enough to resist these plundering
forces, but the abbeys had no defence
against them. In 793, Lindisfarne was
sacked. Alcuin of York wrote to the king

of Northumbria of the shock wave felt at
both the unexpected swiftness and the
unprecedented blow of the desecration:
> ". . . never before has such a terror
> appeared in Britain as we have now
> suffered from a pagan race, nor was
> it thought that such an inroad from
> the sea could be made."

Alcuin was one of a number of Irish-
taught scribes who had been invited to
his court by Charlemagne to initiate the
development of the Carolingian school
of calligraphy. Irish art and learning
were at their height when the Vikings
struck, ravaged the churches, destroyed
books, shrines, and reliquaries. On Iona,
most likely, the sumptuous Book of Kells
was produced in preparation for the bi-
centenary of St Columcille's death in
596. The work was interrupted by the
Vikings, and the book was removed to
Kells for safe keeping.

Countless other masterpieces of Celtic art were looted and taken off to Scandinavia, where they still turn up in Viking graves.

But despite the havoc which they wreaked at first, the Scandinavians gradually settled permanently in Ireland, founding cities such as Dublin in the year 1000, Waterford and Limerick. They changed the lifestyle and culture of Ireland, bringing her into renewed contact with Britain and the Continent and were eventually absorbed into the native population, so much so that even after their defeat at the battle of Clontarf in 1014, their contribution to Celtic art had become a part of the Irish heritage. The Vikings' influence on Celtic art, however, waned drastically after Clontarf. Despite continued contact with England, which remained under the Danish rule of King Cnut

from 1013 to 1042, the defeat of the
Vikings in Ireland so soon after the
foundation of Dublin must indicate
that the pure Viking style of many of
the artifacts excavated there was a
shortlived and limited influence. Such
influences as have habitually been
imagined to be at work in Celtic art of
the eleventh and twelfth century
should be revised. Many of the late
masterpieces of Irish art in those
centuries should really be redefined
by terms that refer to their formal
roots in Celtic, and particularly Irish,
rather than in Viking art.

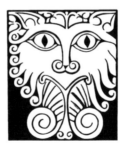

EARLY VIKING STYLES

URING THE EARLY VIKING PERIOD a number of distinctly Scandinavian styles were current, such as found on the Oseberg and Gokstad ships, which are all grouped under the label Style III.

Fig. 8 Table of Viking Styles

Style	Dates
Style III	> 850
Borre	840–980
Jellinge	870–1000
Mammen	960–1020
Ringerike	980–1090
Urnes	1050–1170

The end dates given above for the Ringerike and Urnes styles particularly apply to Ireland, where they developed as part of Irish Romanesque art. Both styles ended sometime earlier in Scandinavia, where they were displaced by Continental Romanesque.

Fig. 9 Detail from Broa Mount

A good example of the early style is the type of animal found on the Broa Mount. The head is very small, the body pierced by holes which break through the edge and then continue as simple knots, such as the triquetra or three-cornered knot as here. The knot actually creates crossed front legs on this sample, leading to three curved talons and a long, curved thumb woven through the pierced body. Later, in the Jellinge and Mammen style, two or three such talons became commonly attached to knotwork ribbons with no apparent reason, often divorced from their original, anatomical reference.

The bird from Broa is pierced at the
neck with a triquetra knot. Below is a
hole in the midsection, through which
a thin hook spirals from the tail. The
wing passes through this spiral making
a third body piercing, while the bird's
foot is a small, vestigial version of the
eagle's claw. Tiny feet and heads are
typical of the early Viking style. This is
a Scandinavian development, such
extensive body piercing being especially
peculiar to the Style III Viking animal
patterns, and nowhere found in Celtic
art of the same time.

On the following pages, we have the
second motif in the Viking repertoire,
the quadruped. The Celtic equivalent
was the dog, and with the mid-eighth-
century Book of Kells, the lion. The
Viking version more often has beak and
talons, suggesting griffins if anything.

Fig. 10 Bird Motif from Broa, Halla
 Gotland, c. 800–825

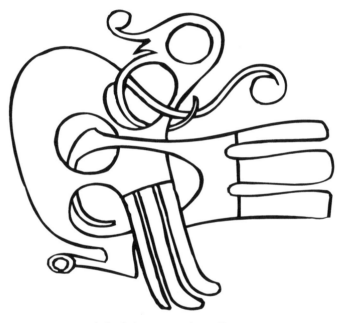

On a gilded bronze bridle-mount, from the
start of the Viking period, this Broa bird is
descended from the eagle of earlier times, but
has two interlocking planes, the wing and tail
perpendicular to one another. Also, the largest
hole is egg shaped.

Fig. 11 Griffin facing right,
 Broa, Gotland, c. 800–825

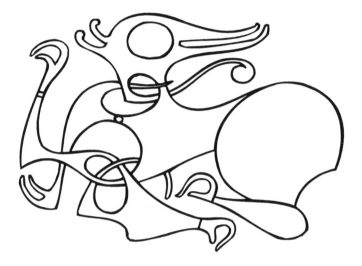

The head of this beast seems ambiguous. It
could be looking in either direction, but I take
it to be looking to the right, of the page. It
has long curved jaws, the lower jaws curling up,
and it has two short ears pointing to the left.
It seems odd that a four-legged animal should
have the head of a bird, but remember, the
Griffin has an eagle's head on the body of a lion.
The head, bust and arms suggest three parallel
planes.

Fig. 12 Quadruped facing left,
Broa, Gotland, c. 800–825

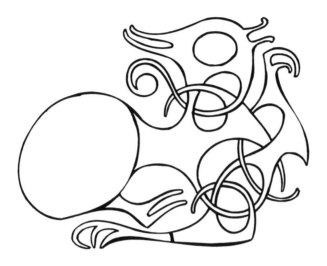

Compare this creature with the last, and
you see it has a similar body, except that this
one has only three legs. Its mate in the last
figure has four legs, but three of them seem to
be front legs. Here the third front leg is just a
sharp prong. The interlacing on both is
basically the simple triangular knot known as
the triquetra knot. The front legs and chest
are twisted in a plane perpendicular to that of
the head and the tail.

Fig. 13 Quadruped with Bird's Head, Broa, Gotland, c. 800–825

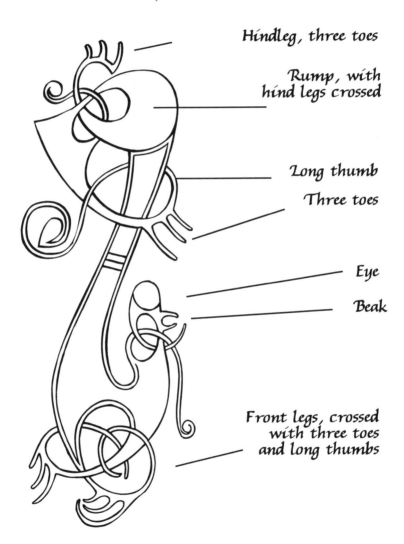

Hindleg, three toes

Rump, with
hind legs crossed

Long thumb

Three toes

Eye

Beak

Front legs, crossed
with three toes
and long thumbs

Fig. 14 Quadruped with Bird's Head, Broa, Gotland, c. 800–825

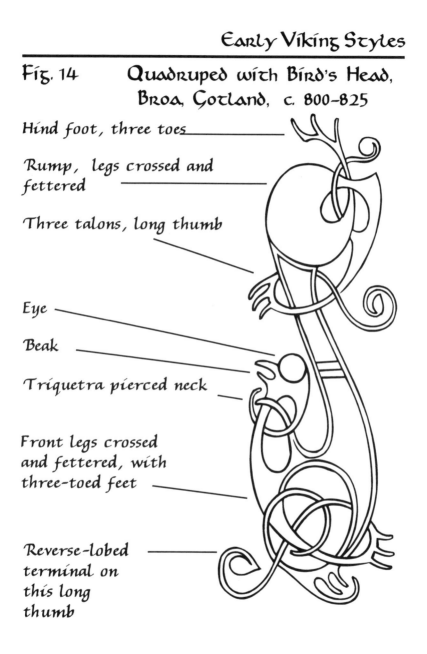

Hind foot, three toes

Rump, legs crossed and fettered

Three talons, long thumb

Eye

Beak

Triquetra pierced neck

Front legs crossed and fettered, with three-toed feet

Reverse-lobed terminal on this long thumb

Fig. 15 Gripping Beasts, Broa

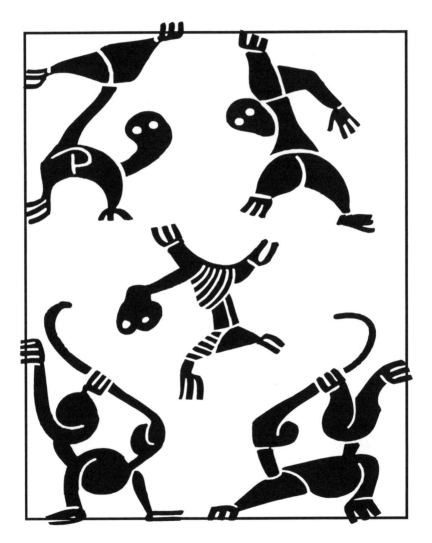

Towards the end of the Style III phase, the gripping-beast motif appeared, as on the Broa mounts, where it is used in a very minor and prototype fashion: just a ganglion of spindly limbs, converging at a common central point, terminating in tiny gripping hands or paws clutching on to each other, or on to the surrounding framework. Sometimes there is a face or mask at the centre, giving it a spidery appearance; other times it has a little mask instead of a hand at the end of one of the limbs. The Broa gripping beast hardly qualifies as a beast: it should be rated as a third-rank critter, compared with more developed birds or quadrupeds of the second rank, and with griffins distinguished by outlined contours as the largest and first-ranking motif. The gripping-beast motif provides a link between Style III and the succeeding Borre style.

Fig. 16 Gripping Beast, Hon, Norway, c. 840

The survival of the gripping beast over several centuries is proof of its widespread popularity. Why so popular?

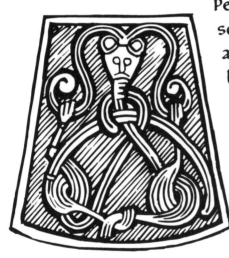

Perhaps it had some cultural association now lost to us. But perhaps it lasted because it filled an important role, provided a minor motif to set off and to contrast with the motifs of the other two, higher-ranking, motifs. This idea of a hierarchy of decorative elements is one to which we shall return later, and meet again in chapters to come.

Fig. 17 ## Analysis of Hon Pendant

 This gripping beast has a bearded face with large, mouse-like ears and long curved horns or hair, a, which it grips with two feet, b, in turn connected to two hands, clasped at lower centre, c. From the left a tail arches across to the right, d. Another tail goes round the neck, e. The neck attaches to the right hip spiral, f.

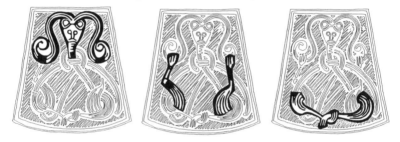

a b c

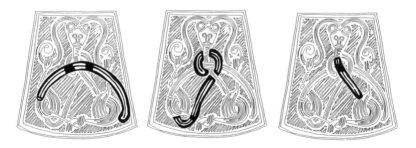

d e f

Fig. 18 Gripping Beast, Borre,
 Norway, c. 840

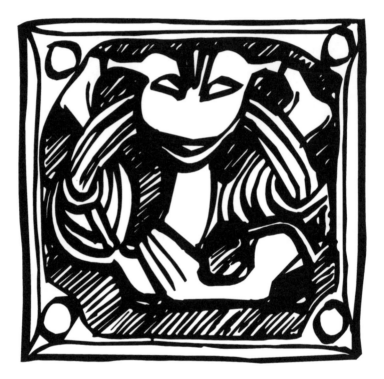

This gripping-beast motif from
Borre is wearing a mask, and its long
body twists somewhat in the form of a
pretzel.

Fig. 19 Analysis of Gripping
 Beast, Borre

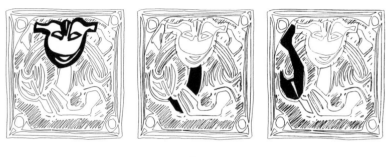

a b c

d e f

The body, d, arcs behind the head, a,
connecting the legs on either side, c, e.
From the right side comes an arm and
hand, f, which grips the neck, b.

Fig. 20 Gripping Hands,
 Alskog Stone

In this marvellously simple knot design from the Alskog stone the ends of the s-shaped ribbon become hands, each with a long thumb. The motif is repeated on the same Gotland picture stone in a border, as below.

Fig. 21 Continuous Border
Alskog Stone

From the same painted stone as the last figure, this pattern could be read as biting snake heads. It may also have been planned as gripping hands, with fingers painted on it, as below. The placing of these two patterns on the same stone seems to suggest a derivation of the gripping hand from the snake-headed knot motif.

Fig. 22 Tile pattern from the
 Alskog Stone

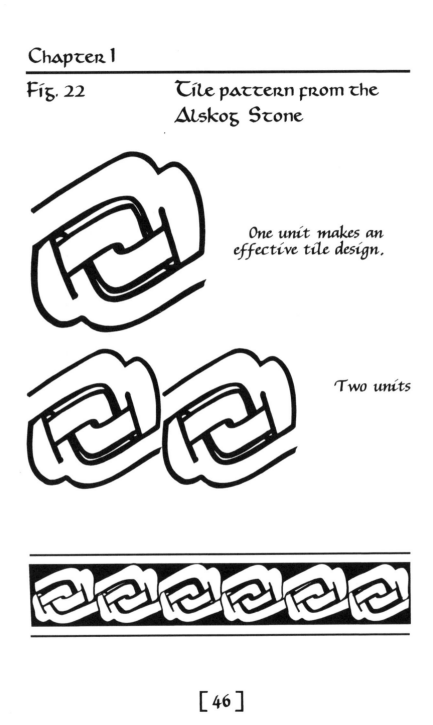

One unit makes an
effective tile design.

Two units

The biting-snake motif on the Alskog Stone is a very reduced form of the knot-work border with a hand at the ends of the ribbon. This resembles the simplest kind of animal pattern, where a loose end of a knot is given a small head. The snake head is shaped like a hand, the lower jaw corresponding to the thumb, as in a glove puppet.

This design is almost archetypal in origin; examples of the serpent-headed knot appear in ancient Mesopotamia, for example. Certainly the Anglo-Saxons were familiar with the motif in their jewellery, in the early seventh century. It is absent from the Book of Lindisfarne. It does not appear in Celtic manuscripts until the time of the Book of Kells, c. 750, and then it is used with birds or animals, chiefly as a second-rank filler comparable to the gripping beast in Viking art.

BORRE STYLE

The early ninth-century Broa style continued on from older Scandinavian traditions, and developed a hierarchy of decorative forms with the gripping-beast motif at the bottom, birds and beasties in the mid-range and full-fledged dragons and griffins at the top of the scale. About this time a new style emerged, named after a famous gold hoard found in a place in Norway called Borre.

This is the first new style we can definitely attribute to the Vikings. It was applied to filigree patterns in wire work. The Borre style produced various forms, hammer-headed owl masks, for example, among other motifs that fall beyond the scope of this book, as they had no impact on Celtic art whatever, perhaps because they appear to have

spread more to the east than west.
Some techniques of Borre metal work
were generally adopted into Celtic art,
however, such as false filigree. In early
times, fine wires were used consisting
of the tiniest beads of gold solder. In
the Viking period, false filigree became
common; a strip of metal was soldered
edge-up on a surface, then dented on
the top edge with a knife blade. This
was then covered with gold foil, and
the result (at a distance) was like
beaded goldwork.

Borre style relates to Celtic art
chiefly as the supposed inspiration of a
style of knotwork popular in the north
of England and the Isle of Man, called
Borre Ring-chain, or, more exactly,
Manx Ring-chain, or *Gautr's Ring-chain*,
after a classic example carved on
Gautr's Cross in the Isle of Man.

Fig. 23 Gautr's Cross, Isle of Man, c. 925–950

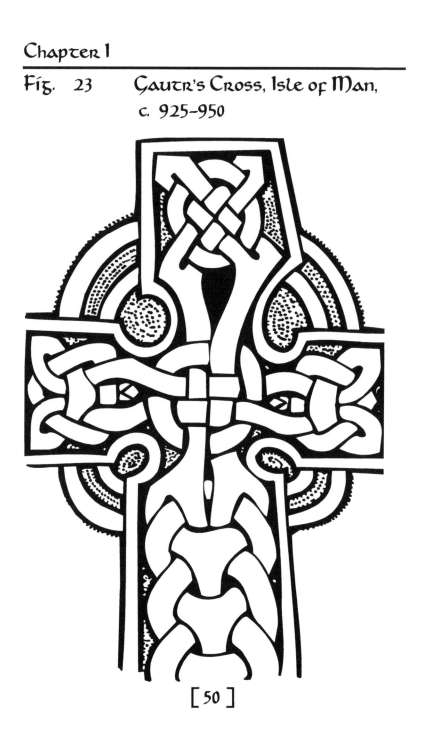

Fig. 24 Gautr's Ring-Chain,
 Isle of Man

This slab carved and
inscribed by Gautr
Bjornsson at Kirk
Michael, is one of the
earliest of a series of
carved crosses on the Isle
of Man. The central
border on the shaft is a
type of ring-chain motif
common throughout
Scandinavia, and is held to
be a typical element of the
Borre Style. The ring-
chain is common in
Northern England. This
sort of knot was used
throughout the Viking
period wherever their
influence was felt. It is
mirrored on a central
axis, and so may be split
to reveal its derivation
from the triple braid.

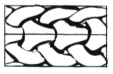

a Split ring-chain

b Triple braid

Fig. 25 Gripping Beast, Vaerne
Kloster, Norway, c. 825

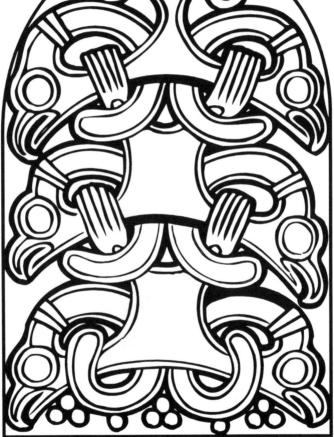

Fig. 26 Details from the Vaerne
Kloster Mount

The pattern on this mount has a
central backbone of hollow rectangular

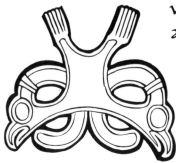

vertebrae, with heads
and hands sprouting
from the centre box
corners, gripping the
next unit above and
below it. Each unit
has two heads and
has two heads and

two hands, mirrored symmetrically, so
that it can be sliced in half, as below.
This half actually makes more sense
anatomically, the fingers of the hand
corresponding to tail feathers.

Fig. 27 Horse-collar, Mammen,
 Denmark, c. 860

Pigtail from dragon's head

Hip

Hind leg

Horn on forehead

Nose curlicue

Human figure

Secondary snake

Claw

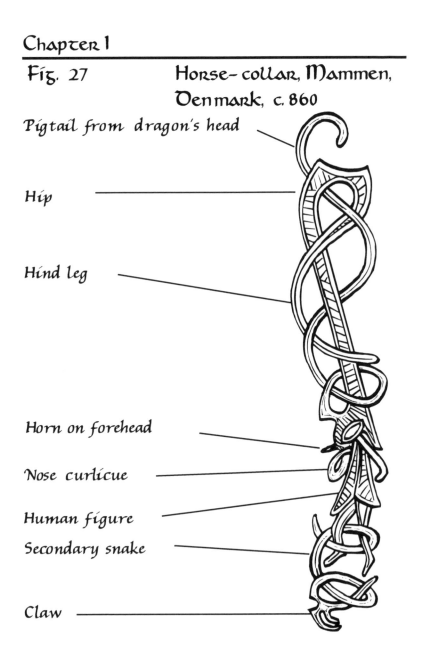

Fig. 28 Clawed-foot Knotwork Treatment

JELLINGE STYLE

On a horse-collar from Mammen, Jutland, appears a stretched version of earlier animals. One pattern shows a human figure being swallowed by a serpentine dragon with a long lip coiled back on itself, like an elephant's trunk. From its forehead juts what looks like a horn, and its head sports a pigtail, winding back along its length.

Another interesting feature is the secondary, headless serpent fettering the ankles of the dragon's victim. Its purpose is strictly to fill space. However, at a turn in the path where it might be expected to widen into a corner, it is embellished with a two-toed claw instead. The taloned bend became a big part of Scandinavian art from the tenth century.

Fig. 29 Jelling Cup Pattern

The Jellinge style takes its name from the ornament on a silver chalice found at the royal burial site at Jelling, Jutland.

a *Interlaced pair of Jellinge animals*

b *Single Jellinge animal*

Fig. 30 Jellinge Nostril Curlicue

The Jellinge animal is long and
thin, with an uncurled extension of
the nostril spiral, usually referred to
as a *lip-lappet,* but which I see as a
nostril curlicue.

Fig. 31 Jellinge Open Hip Treatment

A trademark of the Jellinge style is the centreline dividing the length of the pigtail.

The body of the animal is usually inlined, and has a central band running along its length.

Another thing to note is that the spiral at the hip is open, curled in a tight coil on the underside, and often extending into something like a tail from the back. In the later Mammen style, the hip spiral became very much more pronounced.

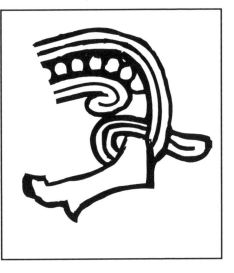

THE MAMMEN STYLE

HE MAMMEN STYLE is a development of the Jellinge style, with more impressive animals, bigger, less ribbon-like bodies, pronounced hip spirals and tendrilly knotwork. The animal's bodies are usually given in-lined contours which are painted with dots on stonework, or filled with pellets (billeting) in the form of carved ivory bone or metal.

Fig. 32 Bird, Mammen Axehead

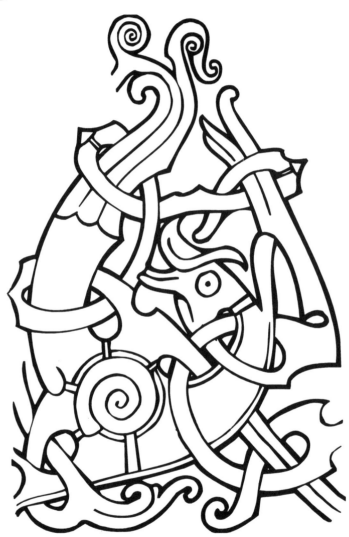

Fig. 33 Mammen Birdhead with
Feathered Topknot

The style is named for the design
on an iron axehead dug up in Mammen,
Jutland. One side of the axe is covered
with a lyre-shaped bird, with its head
thrown back, a round eye and a gaping
beak with a nostril lappet and banded
cheek. There is a branching
from the swelling
at the first sharp
bend of the top-
knot, but this is
plumage, surely,
and not foliage.
Its foot is reduced
to nothing, and the leg swells from the
lower left up to the banded hip spiral.
To the left is the tail with three flam-
boyant feathers leading upwards,
while to the right the neck and head
also come out of the big spiral which is

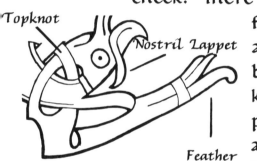

Topknot

Nostril Lappet

Feather

Fig. 34 Tendril Mane

the centre of the whole piece. A fourth
tail feather loops around the leg.

The tail feathers of the Mammen
bird branch into curling fronds, more
like Durrow-style Celtic spirals than
the Carolingian acanthus leaf from
which it is supposed to be derived.
The tendril might be called foliage if it
is part of a plant; if part of a bird, then
I read it as a tendril of plumage, not of
leaf. Similarly, if the tendril occurs as
part of a lion's mane, I take it to be a
curl of hair, not vegetation.

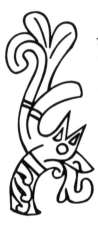 A good example of tendril
mane and tail is that of the
lion on the royal memorial
stone erected in 984 by King
Harald Bluetooth, in memory
of his mother and father. The
stone is an eight-foot tall,
three-sided red rock, one side
covered with runes that tell

Fig. 35　　　Lion and Snake, Bluetooth's
　　　　　　Memorial, Jutland, c. 984

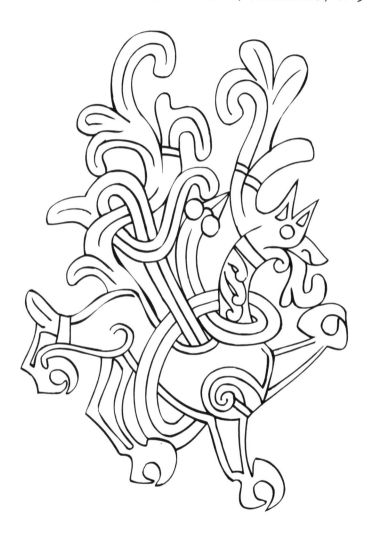

the circumstances that led up to the
memorial. The other two sides are
carved with figures: a lion and serpent
on one, and a fettered figure with
outstretched arms on the other. The
king's mother was Christian, but his
father remained pagan. The figure of
the lion is the father's family crest or
totemic animal, the royal Danish lion,
in a form not far from the Pictish dog
or the Celtic lion symbol for St Mark
the Evangelist. The Danish lion also has
a snake round its middle. Now though
the lion often appears with a snake
in the Book of Kells, yet in Viking art
the combination could refer to the
Great Beast of Viking mythology, often
shown with a great serpent twined
around its neck, with both their
tongues intermingling in an arche-
typal dialogue. The great snake is

Fig. 36 Thorlief's Stone, Man, c. 950

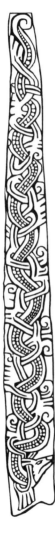

prominent along an edge of Thorlief's Stone.

Harald's father, Gorm, would have appreciated the heraldic iconography with respect to the old tradition, while his mother, Thyri, would have approved the chaste, almost ecclesiastical style of the carving, the very form itself based on the carved stonework of Celtic Ireland and Scotland, Viking-Celtic crosses of the Isle of Man, and the Anglian Crosses of northern Britain. Bluetooth also portrayed the crucifixion figure on the side dedicated to Thyri, but it is an enigmatic picture of a bound Christ, a strong visual

Fig. 37 Tendril Tail of Mammen-
 Style Lion

reference to a traditional pagan icon.
The skilfully blended dedication of
Bluetooth's canny compromise, reflects
the times, for Scandinavia was barely
reconciled yet to the Christian faith,
and had a rich, ancient heritage of its
own sacred art.

Another very important thing
about Harald Bluetooth's Stone is that
it is the first proper stone sculpture
in Scandinavia. He introduced
the art of stone carving among
a people more used to carving
wood.

He erected the stone to
his parents in 984, and the
Mammen-style designs which
he commissioned for it show
that the style was well
established in the 980s.
Celtic artists of the time

Fig. 38 Tendril Tail of Bird

readily took to Harald's compromise,
which led to the survival of Viking
styles in Ireland, elements of which
were absorbed into the ultimate Celtic
animal style, the 12th-century Irish
version of Urnes style.

The tail of the royal lion forks and
branches, and does vaguely resemble a
plant, a staghorn fern as much as any-
thing. Yet it must be read as a tail,
with heraldically stylised
hair curling in heavy locks.
There is a precedent for such
trilobe tassels on the end of
the lion's tail, particularly in
the Book of Kells, a couple of
centuries earlier. The lion's
mane itself has curls down
the neck that are exactly
the style of Celtic
manuscripts. And the

Fig. 39 Animal, Thorlief's Stone
lion has that rampant stance which was
widely sown throughout the Germanic
heartland by way of the decorated Gos-
pel books of Celtic monasteries, going
back to the Book of Echternach, of about
700. But the eagle talons on the feet of
Bluetooth's lion are pure Viking, and its
style is Mammen, though lacking the
usual pellet filling and clock-spring
spiral hip. The only thing the lion
shares with the Mammen Axehead bird
is the almost Mayan plume treatment
of both their tails.

A good example
of Mammen-style
pelleting may be
seen on Thorlief's
Stone from about the same time on the
Isle of Man, put up by a man whose
name, Thorlief, reflects the strong
early Viking presence there. The carver
is familiar with Mammen-style

billeting, though uncertain as to the form, as seen from the ambiguous leg and topknot treatment and the floating clove-hitch knot behind the head. He seems to have modelled his stone-carving technique on that of ivory which does lend itself to billeting, unlike stone. His work from the mid-tenth century shows the Mammen style on the verge of blossoming. The flower is fully opened in the carved ivory decoration of the Bamberg casket which I shall explore in the next chapter. Relating Bluetooth's lion to that of the Bamberg casket, David Wilson has called it "a rather ponderous and formal lion entangled with a snake. . . but its heavy quality removes some of the life from the lion scene of which a more vivacious variant can be seen on the Bamberg casket". I disagree. The lion is stepping down lightly, licking its raised forepaw like a real cat, *fig. 35.*

Fig. 40 Lid, Bamberg Casket

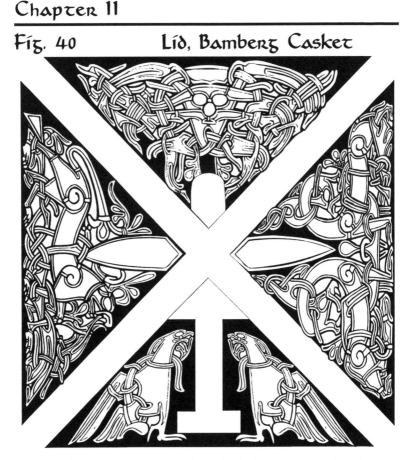

The Bamberg casket lid has four panels. The top one is a face, the bottom is a pair of birds. Either side are animals with trees, a lion and a snake on the left, and a pair of dragons on the right. The shapes dropped out around the centre are for keyholes, to lock the lid.

THE BAMBERG CASKET VARIATIONS

HE CASKET IS A JEWEL BOX, with wonderful designs on the sides and the lid, which fascinates me on several counts. The artwork is of the first order despite a few loose ends, apparently more acceptable to Scandinavian than Celtic taste, and the sides are similarly adorned. Nevertheless, let us just take a look at the lid design alone.

Fig. 41 Face, Bamberg Casket,
 Upper Panel

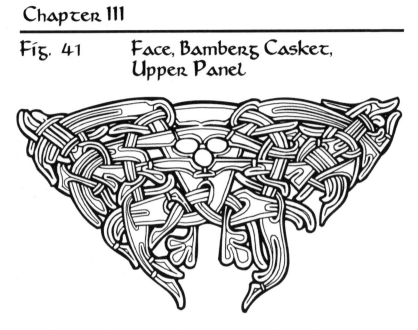

Each of the panels is unrelated to any
other except for a common technique,
billeted bodies and pelleted back-
ground, not shown here. Yet the top
and the bottom panel do relate subtly.
They are both aligned on a vertical axis,
for the upper panel can only be read in
one direction, since it is a human mask.
This face gives a clear direction, as if
the words, "this way up" were spoken
aloud.

Fig. 42 Side Panels, Bamberg
 Casket

The other panels point towards centre,
but the lower one shares the same
vertical axis as the upper mask.
The remaining two panels
on the left and right
side of the lid also
point towards
centre,

but
both the
lion, right,
and dragons, left,
are tangled in a tree.
Thus the artist relates the
panels crosswise in two ways:
the natural division of a square by its
diagonals, the diagonal cross, and the

Fig. 43 Cross Figure Outline,
 Bamberg Casket

vertical and horizontal
axes of the upright cross
as emphasised by the
tree panels.

In any cross the
upper and lower arms
refer to the vertical
principle while the left
and right arms of the
cross refer to the hori-
zontal plane.

The blank keyhole areas also form a
cross, highly suggestive of a human
figure with outspread arms. If so, the
mask of the upper panel is positioned as
the head of the figure.

The keyhole space in the lower
panel would suggest legs and feet. Is
it just a coincidence that the figure
resembles the ground plan of a church?

Fig. 44 Dragons in a Tree, Bamberg

Probably, but to a churchman it would irresistibly suggest the figure of the crucifix. He would also see three evangelist symbols, The Man of St Matthew, the Lion of St Mark, and the Eagle of St John.

Why the Dragons should replace the Bull of St Luke would stimulate lively speculation. It could be argued that the Dragons are not the theme of the panel, so much as the tree which they inhabit – the Tree of Life, or the Inhabited Tree. Or, that they refer to the

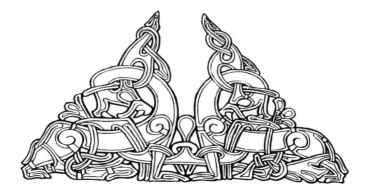

Fig. 45 Lion in the Tree, with Snake

Serpent in the Garden, and relate the
Tree of Eden, to the Tree of Crucifixion,
the Holy Rood. But then, equally, it
could be argued that the dragons had
heraldic significance, family crests of
the household for which the casket was
commissioned, for instance.

Moreover, just as the Lion of Den-
mark adorned the grave of Bluetooth's
pagan father, alongside an ambiguous
crucifixion scene, here another serpent-
belted lion marches through the foliage
of a plant growing out of a pot, here
reduced to a wedge, at the lower left.
A second serpent entwines
among the branches on
the lower right. The
tree is broken into
three segments,
and there are a
couple of short

Fig. 46 Bamberg Eagles

lengths, which might be worms, or the
artist may have slipped up.

Part of the tree is integrated into
the keyhole shape, unlike its opposite
panel, where the same shape points to
the gourd-shaped pot from which the
Dragons' tree grows. The Dragon tree
is all one piece, and its pot is distinctly
rendered, though upside down.

The last panel is the lower one,
filled with two eagles, flanking the
shaft of the keyhole cross. Again, as in
the mask panel, there is no foliage in
the eagles panel. Like those of the
Mammen Axe Eagle, these tendrils are
all feathers.

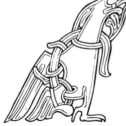 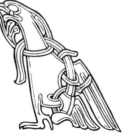

At first glance, it may seem that the
eagles sprout fronds of vegetation, but
a closer look confirms that the tendrils
here are all feathers. From the back of
the head, across the neck and up under
the chin a feathery topknot splits at the
end into three. The artist, perhaps on
purpose, has shaped the three-lobed
end of the topknot like a hand with a
finger pressed against the point of the
beak in a gesture of hush or wonder.
The rest of the knotwork is all tail and
wing feathers. The base of the tail is a
triple knot, one lobe of which forms
the tail. A tail feather curves back and
ends in a heeled terminal. A second
lobe is buried in the bird's body just
behind the leg. From here a long
plume weaves under the tail, over the
heeled terminal, under a recurved
wing feather, and round the neck.

Fig. 47　　　　The Bamberg Eagle

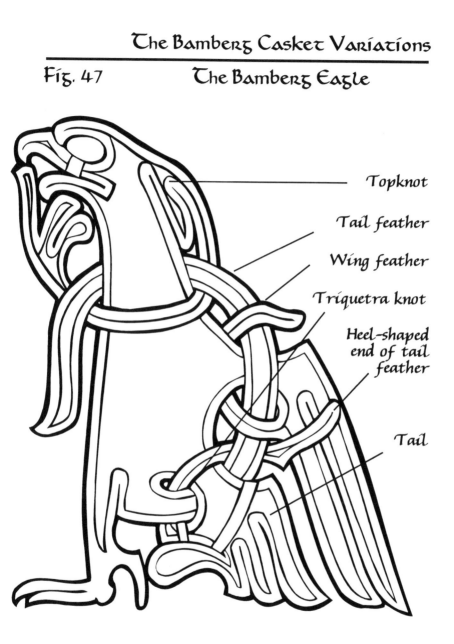

Topknot

Tail feather

Wing feather

Triquetra knot

Heel-shaped
end of tail
feather

Tail

Fig. 48 Bamberg Mask

The Bamberg head is a
face in typical Mammen
style, two bespectacled-
looking eyes and a nose and a
mouth. The beard forks and
curls, weaving through wreaths of
moustaches, eyebrows and hair.
Every strand can be traced to part of the
face, but for a couple of loose ends,
and none of it is foliage.

Where they bend,
strands swell into
claws, some of which
have heeled terminals, and
the beard also ends in trilobe
tassels. There is a loose strand in
the upper left corner, perhaps a
slip of the knife, perhaps a little
snake. A second loose strand arches
through the fork of the beard.

Fig. 49 Bamberg Variations: Mask

The face from the upper panel repeated four times.

Fig. 50 Bamberg Variations: Eagles

The eagles from the lower panel repeated
four times. The resemblance between this and
a cross from a manuscript is striking.

Fig. 51 Bamberg Variations: Lion

The lion prowling through the undergrowth makes
a swastika or rotating cross pattern, when repeated
four times. The dragons' panel has the same lock

Fig. 52 Bamberg Variations: Dragons

pattern as the lion panel, but does not connect to foliage. Both make the same star form, unlike the lock patterns of the other two panels.

Fig. 53 Bamberg Variations: Eagles 1

These two patterns are based on the two eagles of the casket lid, showing fourfold variations of a single tile.

Fig. 54 Bamberg Variations: Eagles 2

This pattern is based on the same tile as the last, only turned 90 degrees.

Fig. 55 Bamberg Variations: Eagles 3

This tile is extracted from the design on
page **86**. Because the eagle is half of the unit,
it can be used alone to create a new kind of
pattern, as we see below and on the next page,
in which just one bird is turned four times
to make the repeat unit.

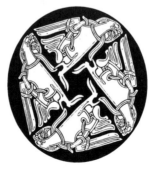

Fig. 56 Bamberg Variations: Eagles 4

Fig. 57 Bamberg Lion

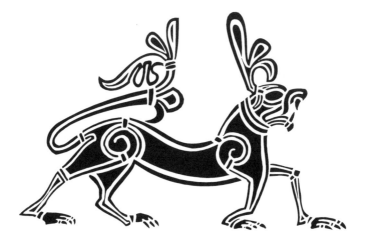

The Bamberg Lion has bent forelegs, as
in a crouching position. Its forelegs
are bent like human legs, like those of
someone inside a lion costume.
The tail is in the form of a horn-of-
plenty, from which springs another
horn, which would appear to be a motif
borrowed from the construction of the
Tree of Life in Irish manuscripts.

RINGERIKE
AND
URNES STYLES

OU HAVE TO ADMIT that the Bamberg casket variations imply a highly developed Viking art tradition underlying the client's selection of motifs to decorate the casket that for the past hundred years has been rumoured to have been the jewel box of Kunisunde, the Queen of the Emperor Henry II of Germany.

Chapter IV

Perhaps the attribution is a romantic fiction such as adheres to anything with the status of National Treasure. Nevertheless, the artist of the Bamberg Casket is very accomplished, and if the contents of the casket were equal to its jeweller's craft it must have contained a precious hoard indeed. The selection of motifs for the box lid betrays a great deal of sophistication, a developed form of Harald Bluetooth's compromise in his choice of motifs for the memorial stone to his parents. His statement of the dedication was secular rather than a liturgical formula such as R.I.P.
-a Viking king's answer to the scruples that required his parents to be buried separately. His mother's dying wish was presumably to be welcomed into Heaven, and his father's more likely to have been the fervent vision of one of the last true Vikings, to be welcomed into the Hall of the Slain, Valholl, if

Fig. 58

Valkyrie, Alskog Stone, Gotland

not into the arms of a valkyrie bearing a leg of meat and a horn of liquor, such as on the much older painted stone of Alskog, in Gotland.

The Valkyrie is readily identifiable in Scandinavian art with her clove-hitched pigtail, pointed shawl, and a trailing gown. She often wears a necklace of huge lumps of amber, and carries a flagon in her hand. On the Alskog stone she greets the shade who rides on Odin's eight-legged horse, Sleipnir. She is a guide of the departed soul, here shown with the emptied cup of his life in an upraised hand, which she will refill.

Fig. 59 The Alskog Stone, Gotland
Ninth Century

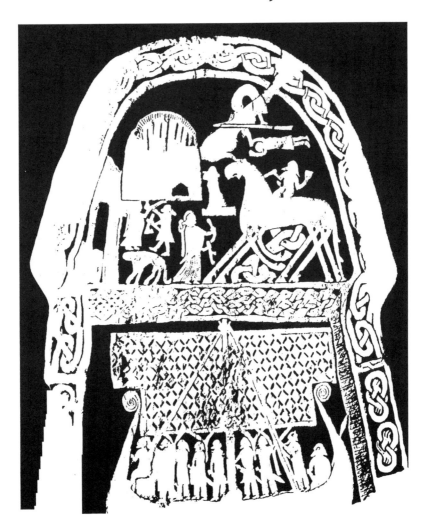

The upper part of the stone is probably
a record of the circumstances of the
death of some important person, or
exploits from his life, or from myth.
The domed hall like a megalithic tomb
at the rear is that of Odin, Valholl, the
Hall of the Slain. The bottom panel is a
beautiful ship with spiral prow and
stern, loaded with Vikings, armed and
holding on to the rigging as if to trim
the sail or steady themselves while the
ship beaches on the Otherworld shore.

A better example of a Valkyrie is
that of the harness mount from
Solberg, Sweden. The character in the
boat is Thor fishing for the great World
Serpent, but, instead of a serpent, here is
a Valkyrie. You can tell by her hairdo,
amber necklace, shawl, and long gown.
Rather than welcoming the soul of the
slain Viking into Valholl, as on the

[95]

Fig. 60 Solberga Mount, Thor Fishing, with Valkyrie

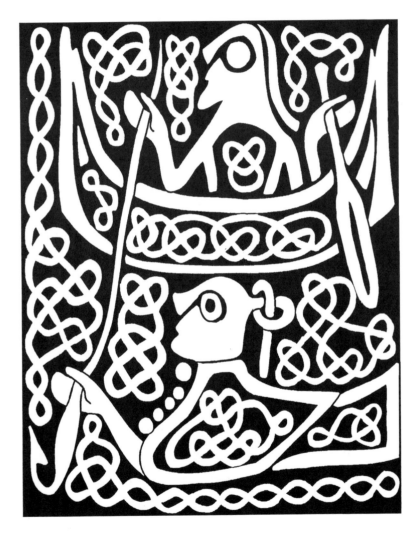

Alskog Stone, here she is a divine helpmate. Presumably, Thor is not taking a break from seeking the World Serpent, which he has to hunt down and destroy or it will rise again to engulf the world at the end of time. He is on this mission, but like many heroes of old, the feminine spirit guides him to his quarry: the Valkyrie is supporting the angler's line by its hook, leading it, and Thor, to find the *Mithgarthsorm*, or World Serpent.

More usually, Thor is shown in a boat fishing with the head of an ox on the hook as bait for the World Serpent. It is shown on the Altuna stone as a snake with a dragon's head ringed by tentacles, like a giant squid, *fig. 61*.

As the story goes, when it took the bait it pulled so hard that Thor's feet went through the bottom of the boat, and so it got away.

Fig. 61 Thor Fishing, Altuna
Stone, Sweden

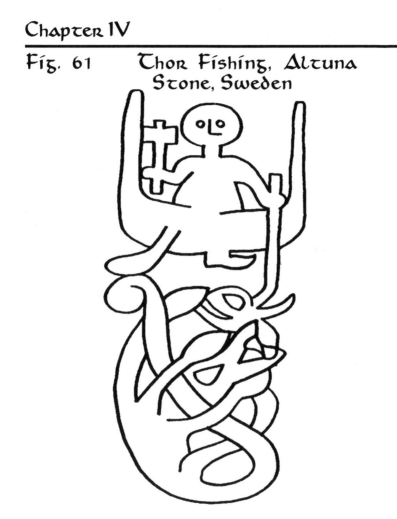

At the Doom of the Gods, Ragnarok,
Thor will defeat the world serpent,
only to die immediately afterwards
from its venom.

The great serpent that appears so often in Viking art from the early period, as on the picture stones of Gotland, was a major theme of the artists of the Ringerike style, and we find it along with the motif of the tree in the Kallunga weather vane. The vane is a quarter-ellipse of gilded bronze engraved with a standard, mounted on the prow of a Viking longboat as a sign that the longboat was, in fact, gone a-viking, or off on a raid. The sight of gilded vanes, like that of the pirate's Jolly Roger, foretold imminent violence and destruction to the victims of those raids.

Pulled up on the beach, a Viking fleet was nonetheless an impressive sight, as recorded on a graffiti sketch from Mammen, carved on a plank by an eye witness with an almost eerily modern sense of perspective, *fig. 62.*

Fig. 62 Kallunga Weather Vane

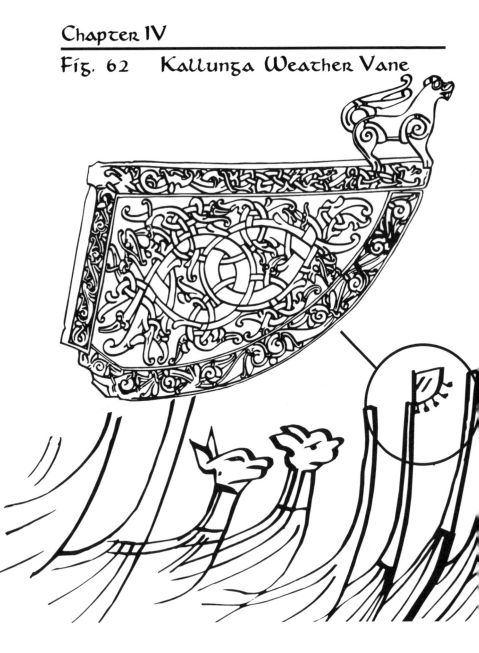

Fig. 63 Scene of Viking Fleet,
 Graffiti from Mammen

In the foreground, there are two dragon
heads, and then a vane on a longboat's prow.
The discovery of this sketch settled an
argument among several antiquarians,
whether the vane was mounted on the top of
the mast or on the prow, as shown here to be
the fact. Such a vane is this one from
Kallunga, with the royal lion figurehead
 mounted on the quarter-ellipse
 of weather vane, decorated
 with dragons and
 snakes.

Fig. 64 Kallunga Vane, Tail
 and Branch Separation

The Kallunga vane has the knotted
serpents on one side, and on the other
the royal lion with a dragon yoked
around its neck, both entangled in the
branches of a tree, bent like a gnarled
briar out of the mouth of a vase, the
pot of which is implied at lower right.

The form of the tail and of the tree
combine in a suggestion of a mask.

Fig. 65 Kallunga Weather Vane
 Design

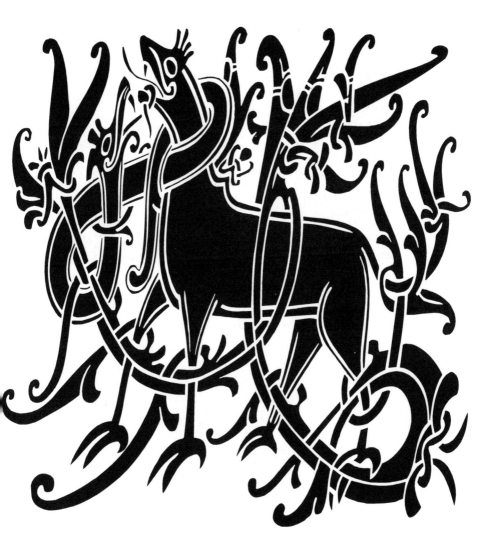

Fig. 66　　Tree and Animals, from the Alstad Stone

Eagle

Tree

Wolf?

Lion?

Rider with Falcon

Toenails

Greyhound

Horse

Rider with Raised Horn (the dead man).

Pot

Fig. 67 Thorlief's Stone, Man,
Cowering Animal motif

The path of the
topknot of this Manx
beast swells wider
where it bends sharply,

along the bottom edge.
The swollen bend is given the form of
three toes, which become toenails on
the edge of the Alstad tree. This feature
goes back to Style III, when the eagle's
claw of the Broa style became just a
mannerism of Viking knotwork, divorced
from the logic of anatomy.

The tree motif carved on the Alstad
stone is from near Ringerike itself. The
tree base, unusually decorated with
spirals and vertical stripes like a Greek
column may be an elaborate planter for
the Tree of Life, though the container of
the Celtic Tree of Life, as also in Viking
art is more usually shown as a vase or
gourd-shaped pot.

Fig. 68 Trial Piece, Spatula,
 Christ Church Place, Dublin

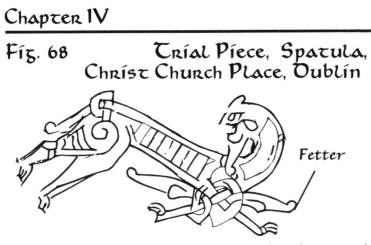

Fetter

Alstad-style animal with crossed and fettered forelegs.

Ringerike style quickly spread afar. The animal style of the Alstad stone turns up on a spatula from Dublin. The piece is unfinished, and the form is Irish, but note its hind leg elbow cap

-typical Viking- and its close, overall resemblance to the equally sketchy Alstad animals.

Mounted Falconer, Alstad

Fig. 69 Lion and Dragon with Tree,
 St Paul's, London

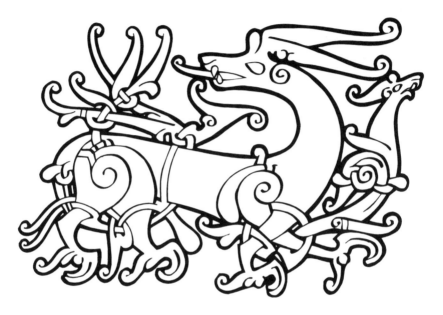

From the old churchyard of St
Paul's Cathedral came another Ringerike
lion, similar in form to the Irish piece,
with front legs crossed over and
fettered with the same knot, except that
the artist has developed the Irish lobed
terminal into a lion's head. The lion
here also has eagle talons for feet.

[107]

Fig. 70 The Heggen Vane

The Heggen weather vane is perhaps the best example of the mature, late Ringerike style, its maturity reflecting the height of Viking culture. It shows too how related all Viking styles had become by the eleventh century. In this image, a little lion steps down from its parent's knee.

Fig. 71 Bamberg and Heggen Lions

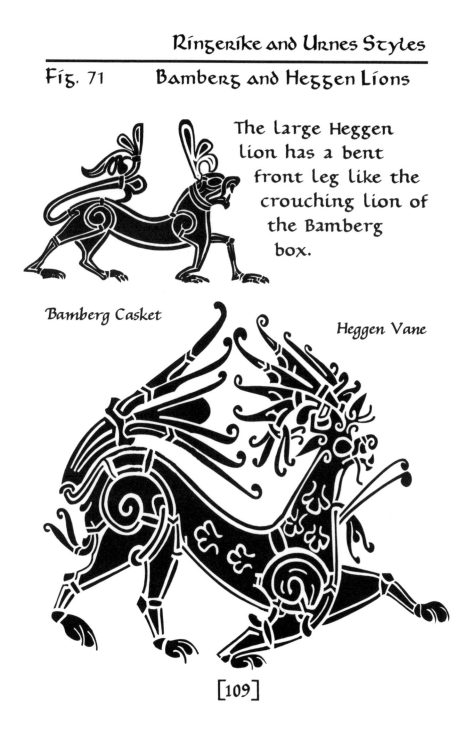

The large Heggen
lion has a bent
front leg like the
crouching lion of
the Bamberg
box.

Bamberg Casket

Heggen Vane

Chapter IV

Fig. 72 Lion from Bluetooth's
 Stone

The little Heggen lion shares the
posture of the lion on
Harald Bluetooth's
Stone. Both are
stepping down,
with a hind paw
raised. The little
Heggen lion also
has a tail wrapped
round its rump,
just like the lion of
St Paul's.

Bluetooth's Lion

A new thing about the Heggen vane
is the perspective of the design. The
artist, probably an accomplished carver
as well as designer, has given the small
lion a three-quarter's toss of the head,
fanning the mane in a plane of its own,
quite other than the two-dimensional

plane of the tail end. In the older,
Mammen style, the design is as flat as a
hieroglyph, viewed in profile. Behind
its pointed ears an erect tuft of mane
sticks up, split in three strands. In the
Heggen model, the mane is viewed
through the ears, with a central part-
ing. The half of the mane further away
is diminished, adding to the quality of
perspective.

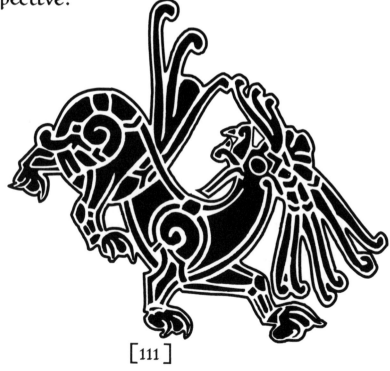

Fig. 74 Lion's Head, Fishamble
 Street, Dublin

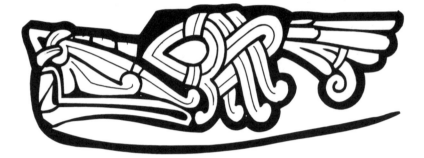

The form of the mane in the three-
dimensional application is seen on the
lion's head carved on the handle of an
awl, found in the excavations of Viking
Dublin at Fishamble Street.

The eye here is the nut-shaped
Ringerike form, but it is banded and the
ribboning is split in the fashion of
earlier Mammen style. Behind the eye
a U-shaped ribbon folded over three
locks is presumably the ear.

Fig 75 Griffin Head, Fishamble Street, Dublin

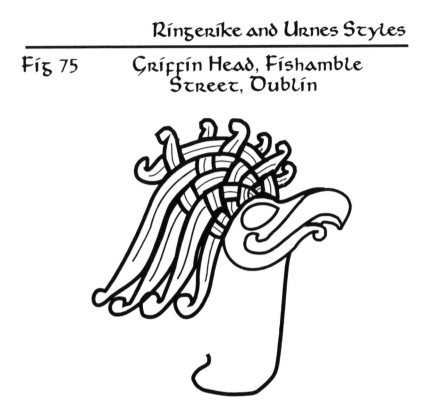

This fine griffin head from another object from the Fishamble Street site in Dublin is resplendent in a fan-shaped mane, which, although wrapped round the head, is the same on both sides, suggesting it was designed in the flat and not with the round in mind.

Fig. 76 Bird Border, Crozier, Ireland

The British Museum Crozier from eleventh-century Ireland has Viking-style ornament on it as well as this simple bird border, which could have been produced in the eighth century. This marks the danger of classifying art styles in a too strictly chronological order, especially in dealing with Irish Romanesque art, which often mixed elements of motifs that had long been familiar with elements of contemporary

style, as was only proper in a tradi-
tional artform that had been in con-
tinuous use for over five centuries.

Birds like this were used on the
eighth-century Tara brooch, for in-
stance. The design is two dimensional,
and is equally at home on the flat page,
pen-drawn as it is in the round, as in
this pierced and cast bronze strip set
edge-on along the curve of the bishop's
crook for which it was made.

[115]

Fíg. 77

Head, Round Tower,
Devenish Island, Ireland

This sculptured head decorates the round tower on Devenish Island. It is traditionally reported to be a portrait of the founder of the Island monastery in Lough Erne and advocate of Colum-cille's mission to Iona, St Molaise.

Any likeness between it and the
form of the mask of the Bamberg casket
does not mean this is "Hiberno-Viking"
style. The head from the high tower,
one of four facing in each direction, is
the peak of a local stone-carving tradi-
tion going back a long way, even to the
very old Celtic cult of the human head,
and was easily accepted in early Chris-
tian iconography as a symbol of the
godhead. The scribal influence is evi-
dent in the economy of line, especially
the key line of the knotted beard that
serves to define the line of the cheek
and jaw. The Lopped-Head motif appears
with knotted face hair in earlier Irish
manuscripts. Given the indigenous
tradition of the head motif in the
Fermanagh Basin, the Devenish head
resembles that of Bamberg only by a
parallel evolution of the form.

Fig. 78 Head, Christ Church Place,
Dublin

The head from Christ Church Place may reflect the taste of the Viking population of Dublin in the eleventh century, as the eyes and tendrils have a certain Mammen or Ringerike feel about them. But the knotwork suggests more of a rack of antlers than a lion's mane, and there is a snake woven among the tines. Could this be a late survival of the image of the antlered stag god of the Celtic world, with his familiar signature, the ram-horned serpent?

Fig. 79 Capital, Tuam, Ireland

The tradition of the carved head
was carried to its ultimate expression
in this marvellous face, with its neatly
barbered moustache. The eyes are
formed in such a way as to read open
or closed, or even peeking sideways. The
brows are extended, curl, and end in
trilobes, and there is a hint of a central
fan of tendrilly mane between them,
but here reduced to a mere sprout. The
mouth is that of a lion. The link between
the brows is Viking, too.

Fig. 80 Ringerike Runestones

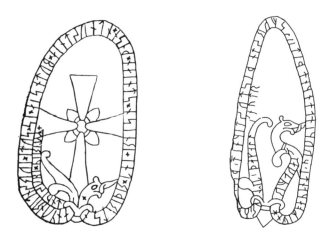

In the early eleventh century, then, Ringerike style was everywhere in the Northern world, and gathered into itself threads of all earlier Germanic styles. But in the second half of the eleventh century, a new style emerged, named after the wooden stave church in Urnes. The style developed in the heyday of the Runestone carvers, and so it is widely known also as Runemaster's style.

Fig. 81 Lion Dragon, St Paul's, London

URNES STYLE

The dragon from the Ringerike-style runestone on the right has a lot in common with the little lion-headed knot tying the crossed legs of the lion of St Paul's, London. Both have lobed tendril tails, and the neck and head of this type of dragon has obviously developed quite naturally from the same form of

lobed tendril terminal.

Fig. 82 Transitional Ringerike–
Urnes Runestone

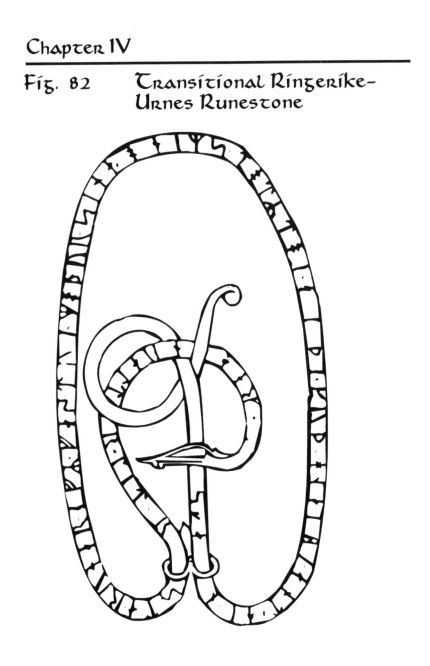

Fig. 83 Urnes-Style Runestone

By now, the head has evolved into a true medieval dragon's profile, with forelegs ending in talons – its anatomy defies classification. A little snake has taken over from the Ringerike binding link, related to the snake round the lion's waist, neck or ankles. It serves as a fetter, embodying the qualities of constraint and attachment, as is in the nature of dragons all the way back to the famous world-circling Ouroborous, with its tail in its mouth, denoting endless potential.

Fíg. 84 Urnes-Style Runestone
with Cross

In Urnes style, the tendril takes on
its own life. Evolved from the lion-
headed, tendril-tailed, serpentine fetter,
such as bound the ankles of the lion of St
Paul's, the Urnes-style Runemaster's
dragon is in turn gartered with a worm
around its middle. The low caste of the
worm is signified by its lack of features.

Fig. 85 Urnes Church, Detail of Arch

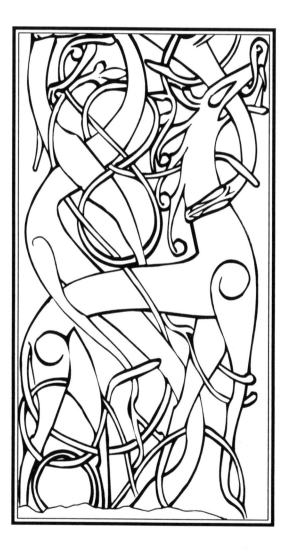

Fig. 86

Urnes Church Door Panel

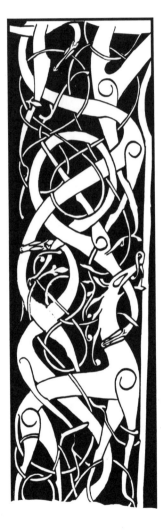

This illustration is of the left half of the door frame of the church at Urnes. The design was part of a wooden stave church, built into the walls of a 12th-century church built over the older site. The Urnes style is irregular and non-repeating. The pattern is pure Viking, a jumble of animals woven together. Some have seen it as a deer grazing on a tree,

Fig. 87 Urnes Lion

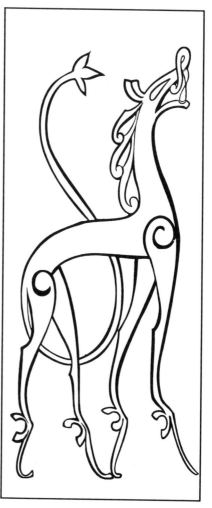

but this view is based on a super-ficial impression only. There is no vegetation in the panel, the tendrils are all body parts: the mane of the lion, the three-lobed tassel of its tail, and long-toed feet, ultimately derived from eagle's talons.

Fig. 88 Dragon, Ancient Babylon

By a fluke, this culmination of the dragon motif in medieval Scandinavia unconsciously reiterates the formula of the ancient Babylonian dragon with eagle's feet and cobra's head.

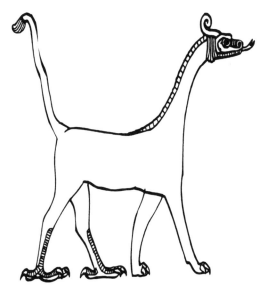

The elegant Urnes lion is solitary, the rest of the pattern being a species of quadruped of a secondary order, shown in profile with only one foreleg

Fig. 89 Dragon, Urnes

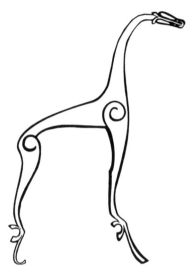

and one hind leg in view, whereas the lion is clearly four-legged. A third order has to be distinguished for the lowly worm, that serves as a lacertine space-filler randomly placed here and there among the tangled limbs and necks of the rest. This creature has already made its appearance as the snake garter of the Urnes-style runestone dragon.

[129]

Fig. 90 Carved Horse-Collar,
 Lom, Norway, 14th century

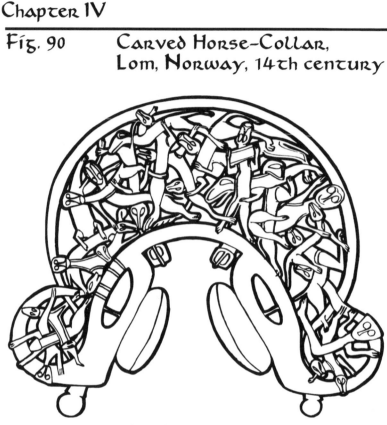

Urnes style died in Scandinavia in
the 12th century, but the form lives on
in this late medieval example: jumbled
biting beasts, some with a snake's head
seen from above, and five with human
faces, not many times removed from the
old gripping beast.

MEDIEVAL CELTIC LETTER STYLE

OW LET US LOOK AT IRISH ART of the Viking period. How far did Viking styles influence Celtic art in the form of illuminated letters? As a benchmark, let us look first at a letter D, from England under Danish rule, to see what we should expect to find if Viking art were applied to letters in Ireland.

Fig. 91 Letter D, Cambridge
 Manuscript, c. 1025

There is nothing like this in Irish work of the time. Compare this pure Ringerike English letter D to the first appearance of tendril-style letters in Irish art, from the chronicle of Marianus Scottus of Mainz, written in 1072. Here we find a squared spiral form of the D that echoes the old Irish majuscule, a griffin with bird head and lion rump, *fig. 92*. The face could have been done three centuries earlier, it is so conservative. The only clue to its actual period is the Viking-style branched knotwork, where before was only a single stem.

Fig. 92 Letters O and F, Chronicle of Marianus Scottus

In the letter F, below, the tendril style is seen more clearly. All the knots are one long tail. Added to lobed tendrils are heeled tendrils with Swiss-cheese holes in them making a third, the lobe-and-hole, or S-curved lobe above the dog's head. Celtic Tendril Style is built up from such lobed tendrils. Still, the woven lobes of the tail may reflect German influence on the Irish scribe.

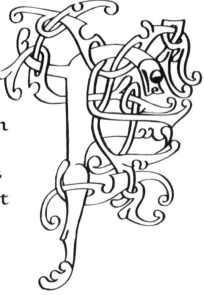

[133]

Fig. 93 Irish-Style Lion, 11th cent.

The S-Curve appears in the tail of this lion, which is otherwise quite Celtic in style. So much so that here the tendril effect is clearly familiar and natural to the Celtic artist.

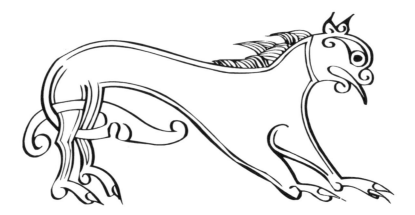

The animal style in medieval Celtic art is as different from Scandinavian as these lions differ from the lions of Kallunga or Heggen.

Fig. 94 Irish-Style Lion, 11th cent.

There is a new quality of three dimensionality in the figures, as in the three-quarter view of the breast of this lion. The lobed tendril here recalls its origin as the ringlet and curl of the lion's floridly tasselled tail.

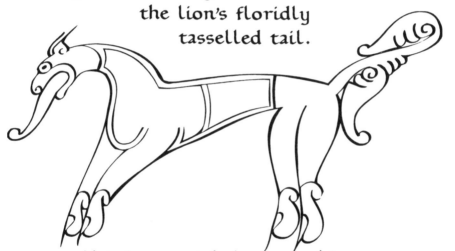

Yet, I cannot bring myself to see this tail as other than a parallel and contemporaneous development in Celtic art going back centuries. It is as much a Classic split palm leaf as a heeled terminal with added lobes and spirals.

[135]

Fig. 95 Letter H, Corpus Christi
 Gospel Book, Oxford, 1140

There is little Viking
influence in this letter H.
The mane is a simple
heeled terminal,
the line of the
mane running
into that of the
cheek. The head
is a study in
line. It makes
you want to pick
up a pen and try to
draw it as you see
it. The knotwork is
quite uncontrived. The lacy filler is
also a study in freely-drawn knots,
sharing keylines with the foreleg and
belly, a virtuoso play of knotwork for
its own sake, despite the path's extra
circuit, not connected to the tail.

Fig. 96 Celtic Lobed Tendril Knot

In style, it certainly differs therefore
from earlier Celtic animal art, but it is
closer to a Pictish dog than a Bamberg
lion, for all that.

In *fig. 96*, the knotwork
differs from the tendrils
that are the root of the
Ringerike style, though both
may be derived from the form
of the heeled terminal of
Celtic spirals. In Ireland,
the lobed terminal is kept
subordinate to the knot,
true to its origin as a
development of the
natural swelling that
occurs in the sharp
turn of the path
where it bends back
upon itself.

Lobed
Tendril

Fig. 97 Letter C, Liber Hymnorum,
 College, Dublin

The notched and
lobed treatment of
the knotwork tendril
is the basis of the
Medieval Celtic Style,
while the lock of the
lion's mane became
the basis of Viking
tendril style: the
same element in both
traditions may be shown
to have come about out
of parallel but distinct
developments.

In this letter C,
from the Trinity
Liber Hymnorum,
c. 1075, heeled
tendrils have been
fitted with ringlet
terminals, S-curved lobes and notches.

It may look like a Runemaster's dragon with a heeled tail, but in fact the body of this dragon ends in a lens shape, like the cross section of a tube. The surrounding terminal with two ringlets and a lobe wrapped about a ring is a swelling in the path of the knot, as it should be in Irish style, not the claw of Germanic knotwork. The body is all one from the back of the head to the tail and back up to the chin, where it turns into a spiral, and joins the lower jaw. This forks to fill the mouth and end in a tassel, by happy chance forming a griffin's beak inside the mouth, but the head is more dog than griffin, with the floppy ear and the bearded chin of a terrier. There is a fine kinship between the shape of the ear here and that of the Heggen lion, but the style is wholly Irish.

Fig. 98 Letter O, Liber Hymnorum

Likewise, this letter O is the work of one steeped in Irish penmanship, a study in continuous key strokes upon which the whole design can be reconstructed freely by a copyist, though hardly an unskilled one.

The topmost terminals add a lens to the ball terminal to form divergent trumpets, as in Celtic spirals. These may be used interchangeably with the bar terminal at the bottom. The dragon has a lappet

from the lower lip, not a Viking nostril curl.

The ears are swelled knot paths, based on a triquetra. One is notched with a semicircle, or dovetailed to an adjacent, overlapping tendril.

The four lensed terminals show a development from simple to complex, the uppermost pair forming two faces, one bowed and bearded, the other with a long lower lip, even arms and legs.

The scribe evolved these masks from the swollen bend of the knot, midway on the right edge, starting with a lens and ball terminal. He added a notch to the bend half-way along the left edge, which makes it look like a face. Then, by bracketing the notch with lobes, he got the mask effect, top right. Substituting a spiral and a lobe, he provided the other face with a beard, top left.

Fig. 99 Letter M, Liber
Hymnorum, c. 1075

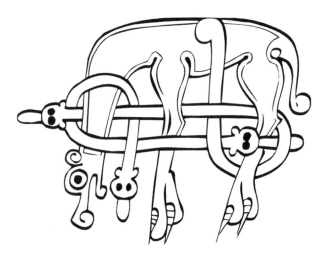

This letter M is from the Kilkenny
copy of the *Liber Hymnorum*, or Irish
Book of Hymns, written by another
scribe in the late eleventh century.
Here he fetters the animal with two
snakes, one of them two-headed, seen
from above. The letter is entirely in
accordance with Celtic animal style,
but the graphic form is sophisticated in
its droll, comic-book style.

Fig. 100 Letter D, Liber Hymnorum

This letter D is typical of the late medieval style of Celtic art. The knotwork is laid on a classic diamond grid, and the composition is centuries old. New is the snake motif, looped in alternating directions. This may resemble the little serpent of the Runestones, but the snake, viewed from above, with ears, gills or horns, was in Celtic art long before the Vikings.

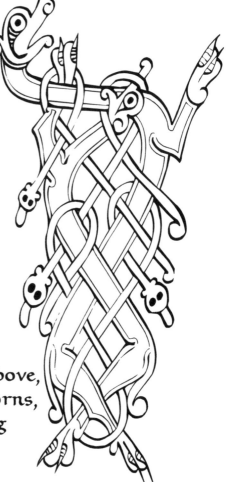

Fig. 101 Letter Q, Harley Ms.

And the faces of the snakes belong more in a child's comic book than on a Viking gravestone. If the form is similar, the spirit could not be more different.

The letters Q and X, from the Irish Gospel book in the Harley collection, penned in 1138, could well belong to the golden age of Celtic illuminated letters, but for a trademark of Ringerike tendrils, one forked and recurved terminal under the dog's throat to the right side of the letter X, like the Kallunga lion's tail.

Fig. 102 Letter X, Harley Ms.

This one Viking element hangs off to one side as if the artist felt unsure whether or not to include it. But anyhow, terms of Viking style such as Ring-erike or Urnes do not apply here, but for this minor detail.

The branching knotwork, lobed and s-curved terminals of the rest of the knot-work is typical of Celtic art of the time.

Fig. 103 Letter D, Cormac's Psalter, c. 1150–1175

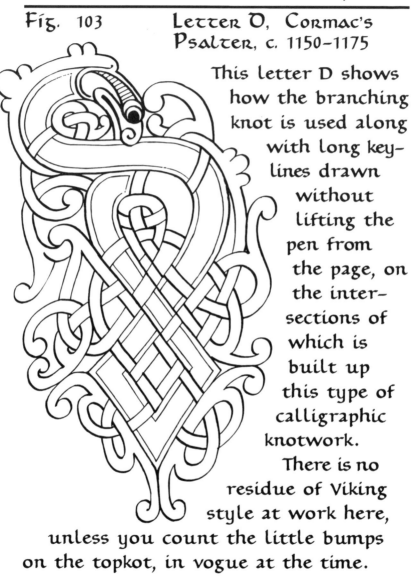

This letter D shows how the branching knot is used along with long key-lines drawn without lifting the pen from the page, on the inter-sections of which is built up this type of calligraphic knotwork.

There is no residue of Viking style at work here, unless you count the little bumps on the topkot, in vogue at the time.

[146]

LATE MEDIEVAL CELTIC STYLE

RISH ART IN THE TWELFTH CENTURY is habitually called *Irish-Urnes Style*. And yet, late medieval art such as the sarcophagus now in King Cormac's Chapel, Cashel, is pure Celtic art.

As Françoise Henry concluded, in the eleventh century the native tradition remained very much alive, flavoured by minor features of Viking animal style and Viking-style knot treatment.

"The impetus of that Scandinavian fashion wanes fairly early in the twelfth century, leaving behind only a vague similarity in the general appearance of the patterns and a common trend pervading these so closely related arts." —F. HENRY

Fig. 104 Sarcophagus, Cashel, Ireland, late 12th cent.

In the Cashel Sarcophagus, the animal is a dog-like lion, with a beard from the lower jaw, not a nostril curlicue. It is bearded like the dragon's head on the letter C from the *Liber Hymnorum, fig. 97*, that seems to have been based on the profile of an Irish terrier. The closest Irish equivalent of Urnes style is that of the Lemanaghan Shrine, but, unlike Urnes, these animals are mouthless and sometimes bearded.

Fig. 105 Details, Lemanaghan Shrine

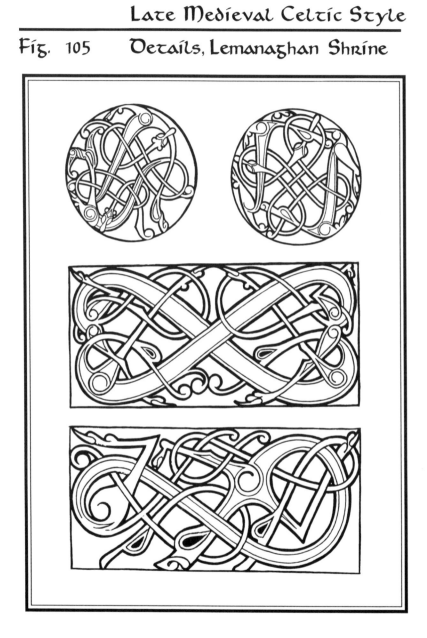

Fig. 106　　Upper Panel,
　　　　　　St Patrick's Bellshrine

Here the tail of the long-beaked animal is branched like the Kallunga lion, but the feet are the ball-and-claw of local design. The lower jaw is set back, and the eyes are round, unlike Urnes-style jaw or eyes.

Fig. 107 Lower Side Panel,
St Patrick's Bellshrine

Fig. 108 Two Wire Filigree Panels St Patrick's Bellshrine

St Patrick's Bellshrine is often cited as a typical example of Irish-Urnes style, but the only thing Urnes about these designs is the backward eye, and it is in a head with a backward-sloping lower jaw, which is Irish. The spiral beastie has Celtic ball-and-claw feet and a round eye. It is a pure Celtic animal knot.

Fig. 109 Wire Filigree Panel,
St Patrick's Bellshrine

Here is a backward-slanting eye, as in
Urnes, but also a pointed head with
round eyes, which is Celtic. The
snakes are alternately looped, but in a
much more complex and organised
fashion than the by now extinct
Runestone variety.

Fig. 110 Details from Shrine of
 St Lactin's Arm, Ireland

The Master of St Lactin's Arm shows
how the backward-pointing eye

associated with
Urnes style may
be arrived at
independently by
a Celtic artist:
these eyes are half
moons with a
tendency to slant
backwards or
forwards.

In one panel of
the Lismore
Crozier is a figure
in Egyptian garb
holding two
snakes, not
Bluetooth's bound

Christ figure but Aaron whose rod
turned into a serpent and ate all of its
fellow snakes conjured by the Pharaoh's
priests, Exodus 7: 10. The square below
is a long-snouted, pointy-eared snake
and the crosslet to the right is one
with a horn and a heeled terminal.

Chapter VI

In the panel from the arm of the Cross of Cong, we find three orders of animal: two are like those of the Shrine of St Lactin's Arm with ear, half-moon eye and heeled-terminal tail, one with front leg, one without. The third and highest-ranking canters like a horse, but is decorated with curls all down its flanks, as is the lion in the Book of Armagh. The shape of its eye echoes that of a Jellinge-style bird, but its nostril curlicue is the lobed terminal of Irish taste. The few scraps of Viking style that do appear here reflect Irish interest in elements of Scandinavian art over the previous five hundred years, which by the twelfth century had become naturally assimilated into the native tradition. For this reason, it is not appropriate to describe the whole of late medieval Celtic art as "Irish-Urnes style", any more than to call all

Fig. 112 Lions, Dragons, Serpents, Cross of Cong

Celtic art of the Early Christian period "Hiberno-Saxon". It leads to confusion and argument over origins to name a style after a particular find place, as when we find Mammen style at Jelling, Jellinge style at Mammen. The same problem argues against creating styles after Irish place-names or things. But, allowing that Irish art in the early Christian period is Celtic, then twelfth-century Irish art should be acceptably described as Late Medieval Celtic Style, and not the provincial derivative that the misnomer "Irish-Urnes" implies.

GLOSSARY

ANICONIC, non-pictorial, abstract.

BILLETING, background filled with circular punch marks, as also PELLETING.

CURLICUE, S-curved lappet, from nose.

ELLIPSE, stretched circle, oval.

KNOTWORK, surface pattern of segments arranged to appear as path alternatingly woven over-and-under itself, shared by both Germanic and Celtic traditions.

LACERTINE, intricately woven, like lace.

LAPPET, a lobe or flap, as of skin, from ear, nostril, tongue or tail.

LENS, a flattened ellipse, pointed either end.

LOBE, a flat, rounded, split-off part of a larger area, such as tendril or lappet.

MAJUSCULE, alphabet of letters, e. g. Irish Uncials, equal in value to block capitals.

TERMINAL, tail end of a knot or lappet.

TRILOBE, lobe divided into three.

TRIQUETRA, three-cornered knot.

LOBES AND TERMINALS

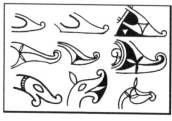

a

b

c

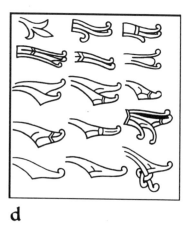

d

a Celtic, 7th century
b Celtic, 8th-9th century
c Celtic, 10th-12th century
d Viking, 10th-11th century

RECOMMENDED BOOKS

H. R. Ellis Davidson,
Scandinavian Mythology, London, 1969
James Graham-Campbell & Dafydd Kidd,
The Vikings, London, 1980
Françoise Henry,
Irish Art in the Romanesque Period (1020-1170), London, 1970
Magnus Magnusson,
Hammer of the North, Myths and Heroes of the Viking Age, London, 1976
Aidan Meehan,
Celtic Design: Animal Patterns,
London, 1992
Celtic Design: Illuminated Letters,
London, 1992
David M. Wilson,
The Northern World, London, 1980;
The Vikings and their Origins,
London, 1980
D. M. Wilson & P. G. Foote,
The Viking Achievement, London, 1979